FIRST ARTS & CRAFTS

Collage

Sue Stocks

With photographs by Chris Fairclough

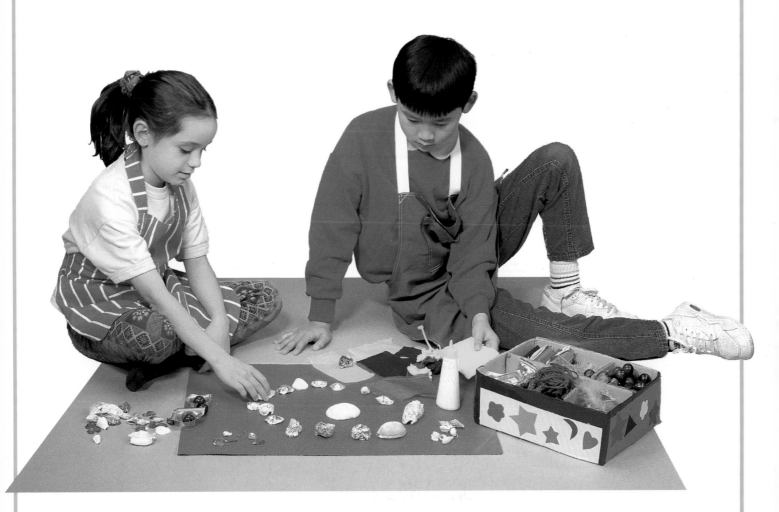

Wayland

FIRST ARTS & CRAFTS

This series of books aims to introduce children to as wide a range of media approaches, techniques and equipment as possible, and to extend these experiences into ideas for further development. The National Curriculum proposals for art at Key Stage One place particular emphasis on the appreciation of art in a variety of styles from different cultures and times throughout history. The series broadly covers the National Curriculum attainment targets 1) Investigating and Making and 2) Knowledge and Understanding, but recognizes that circumstances and facilities can vary hugely. Children should experiment with, and add to, all the ideas in these books, working from imagination and observation. They should also work with others, where possible, in groups and as a class. You will find suggestions for and comments about each section of work in the Notes for parents/teachers at the end of the book. They are by no means prescriptive and can be added to and adapted. Unless a particular type of paint or glue is specified, any type can be used. Aprons should be worn for all projects. Above all, the most important thing is that children enjoy art in every sense of the word.
Have fun!

Titles in this series
Collage, Drawing, Masks, Models, Painting, Printing, Puppets, Toys and Games

First published in 1994
by Wayland (Publishers) Ltd, 61 Western Road, Hove
East Sussex BN3 1JD, England
© Copyright 1994 Wayland (Publishers) Ltd
Series planned and produced by The Square Book Company

British Library Cataloguing in Publication Data
Stocks, Sue
Collage - (First Arts & Crafts Series)
702.8
ISBN 0 7502 1010 9

Photographs by Chris Fairclough
Designed by Howland ■ Northover
Edited by Katrina Maitland Smith
Printed and bound in Italy by G. Canale & C.S.p.A., Turin

Contents

What is collage?

Collage is the art of sticking different materials on to a background of paper or card to make a picture. You can make collages with anything. Look around and see what you can find. This collage is made from shapes cut out of painted paper.

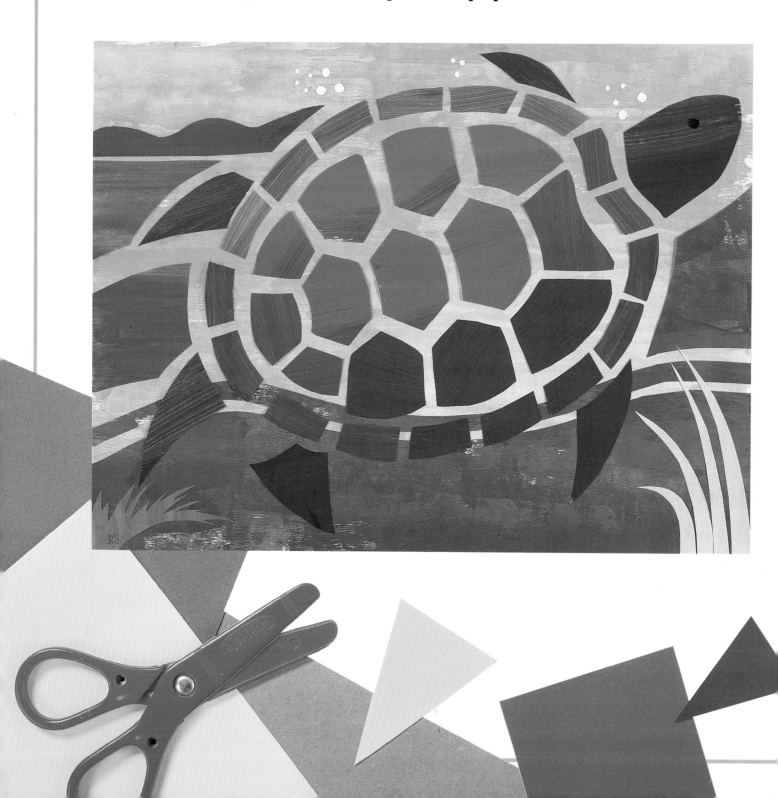

Here are some ideas for things you can use to make a collage – scraps of fabric, wool and threads, beads, dried seeds and pods, bottle tops, wood shavings and sawdust, different papers, corrugated card, leaves and grasses, dried pasta and lentils, sweet wrappings, silver foil and crushed eggshells. Collect as many of these items as you can and put them in a cardboard box.

You will need:

A cardboard box

Scissors

Glue

Different materials for making your collages

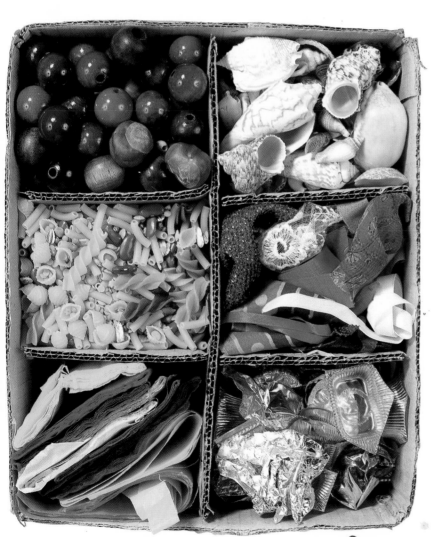

This can be your collage box. Use the different materials you have collected whenever you make a collage. Keep adding to your box as you find new things to use. You may like to decorate your box by sticking some of the things on to it.

Making a collage

You can make a collage out of just one material or out of a number of different materials. You can make very big collages or small ones. Small ones can be made with seeds, beads and thread.

You will need:
Your collage box
Scissors
Glue
Card
Paper

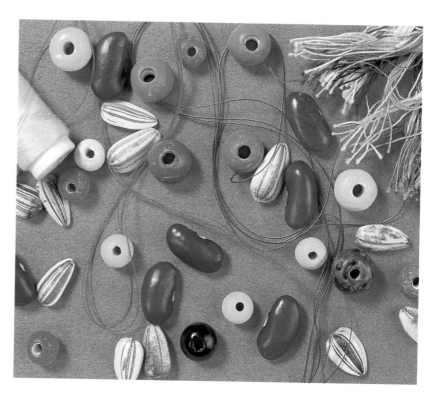

You can cut or tear paper into different sized pieces. Torn paper has interesting edges. You can scrunch it up into different shapes or overlap the pieces as you stick them down.

When you make a collage it is usually best to put in the background first. This can be done by sticking large pieces of paper or fabric over your card before you add the smaller materials.

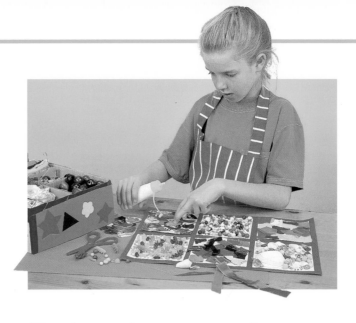

- Cut some pieces of card about 150mm square.
- Choose some materials from your box and practise making patterns by sticking them on to the card squares. You will need to put glue on your card each time you add something.
- Sprinkle some sand on to one of the squares. When it is dry, glue on some wood shavings.
- Try sticking seeds, dried pasta, fabrics or torn paper on to other sticky squares.

Try lots of your own ideas. Collect your squares together and stick them on a big sheet of coloured card.

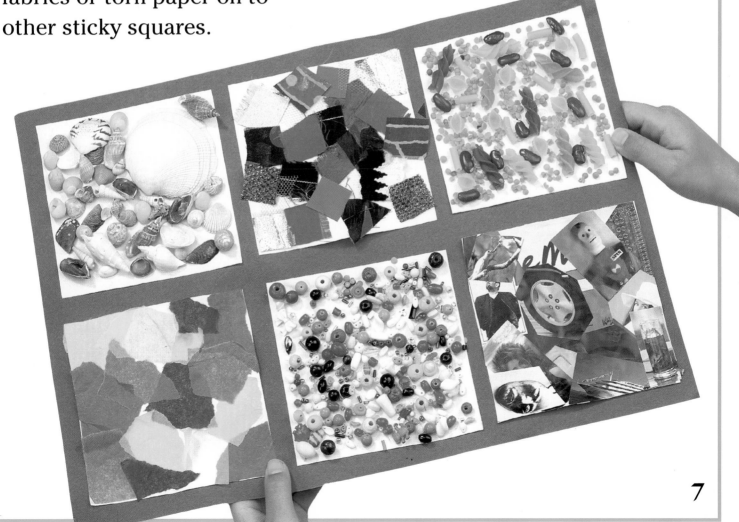

Windows

Windows are all different shapes and sizes. You see many interesting things when you look through windows. Look at this collage of a toy shop. It is nearly 2 metres wide!

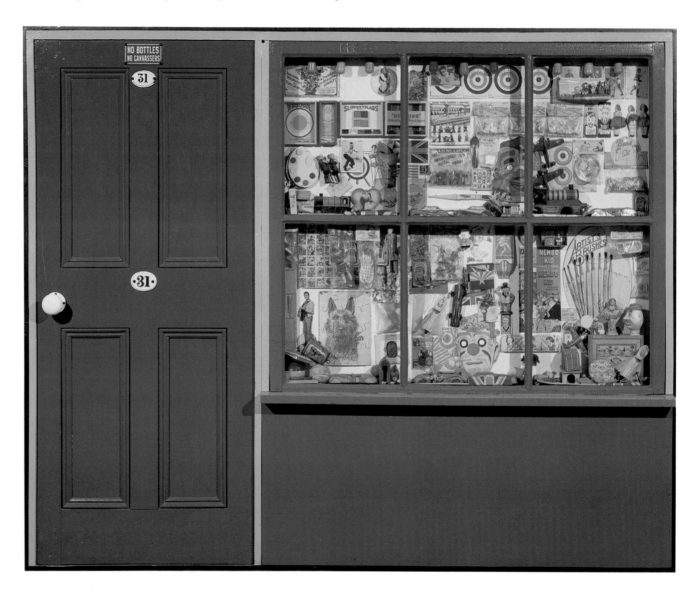

The Toy Shop by Peter Blake (b.1932).

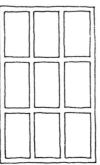
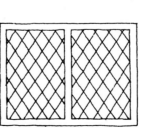

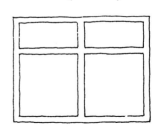

You can now make your own collage of a view through a window. You might be looking out of the window or looking in. If you look out you may see houses, countryside, sky and sea. What else might you see through a window? What would you see if you looked in through a window?

There are windows in cottages and castles, cars and aeroplanes. Can you think of some more? Choose your favourite window to make a collage.

You will need:

Your collage box

Scissors

Glue

Stiff card

Card

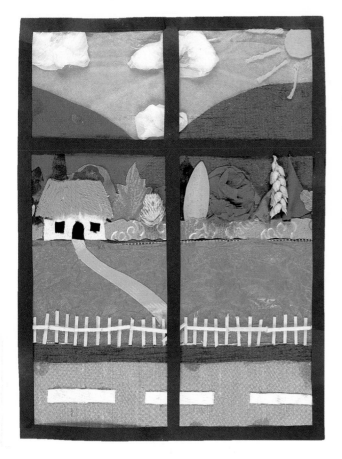

Use as many different materials as you can.

- Make the background first.
- Build up your picture on top by sticking down materials from your collage box.
- Cut a window frame from card and stick it on top of your collage. What shape is it?

When you have finished your picture, hang it on the wall. Next time, make another window with a different view.

Faces

Look at this painting called *Spring*. The artist is famous for strange pictures like this. What do you think of it?

You will need:

Old magazines

Scissors

Glue

Paper

Pencil

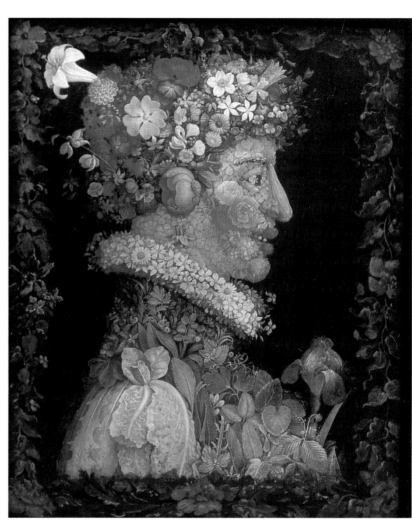

Spring by Giuseppe Arcimboldo (1527-1593).

- Cut out an assortment of eyes, noses, mouths, eyebrows and ears from pictures in old magazines.
- Make a pile of each.
- Cut out any pictures that include different skin colours.
- Make a pile of each.
- Do the same with different hair colours.

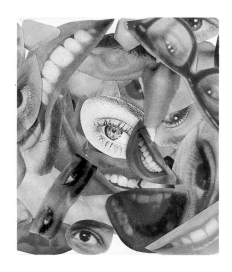

Now you are ready to make a funny face.

- Draw the outline of a head on your sheet of paper. Make it big, and do not draw in the eyes, nose or mouth.

- Use one of your piles of skin colours to make the background of the face.

- Tear the pieces of paper and overlap them when you glue them down.

- Glue on some eyes, eyebrows, ears and a mouth. Choose a big nose!

- Tear and cut paper for the hair and stick it on.

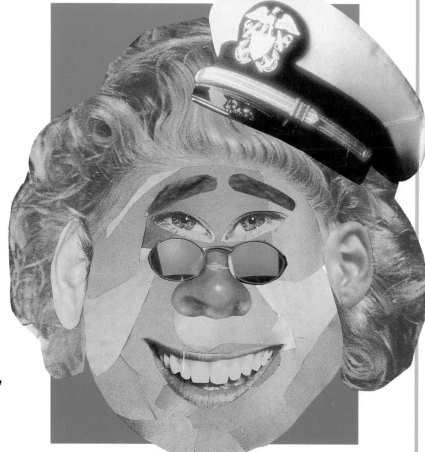

Next time, make a different face. Make a row of funny faces. Which do you like best?

Stained-glass windows

Look at the pictures of stained-glass windows below. Look at all the colours. When light shines through stained-glass windows, the colours are brighter. Have you seen windows like this?

Sometimes stained-glass windows tell a story or make a picture. Sometimes they just make a pattern. The window below on the right was made for a synagogue in Jerusalem, Israel. The picture on the left is the painting from which a window was copied for the new Tate Gallery in St. Ives, Cornwall. Which window do you like best?

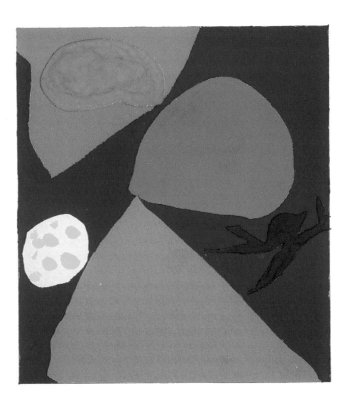

Design for Big Window - Tate Gallery St. Ives: April 1992 (Gouache: 185 x 165mm) by Patrick Heron (b.1920).

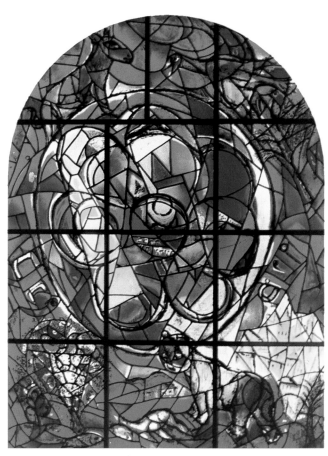

The Tribe of Benjamin from the series *The Twelve Tribes of Israel* by Marc Chagall (1887-1985).

You will need:

Clear Cellophane or white tissue paper

Different coloured tissue papers

Black paper

Scissors

Glue stick (e.g., Pritt)

- Cut some thin strips of black paper.
- Use them to make a window frame.
- Stick the clear Cellophane or white tissue paper on to the window frame. You should now have a window.
- Tear and cut large and small pieces of coloured tissue paper.
- Stick these pieces on to the window. Try overlapping some of them.

Now turn your collage over so that all the sticking is on the back. Hold your collage up to the light. Look at the beautiful, bright colours. See how the colours change where they overlap. You can lay thin strips of black paper over your window to make a different pattern. Tape your finished picture to a window.

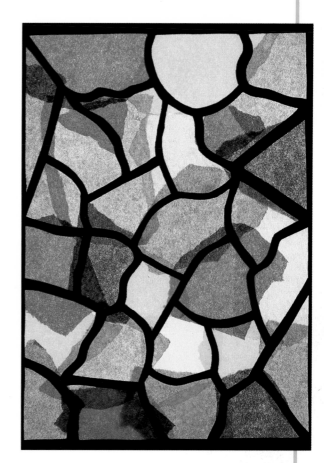

13

Bird's-eye view

Pretend you are a bird, or a pilot in a plane, flying over the countryside. Look down at the ground. What colours would you see? Greens, yellows and browns perhaps.

Think of the patterns in fields that have just been ploughed. Grass and corn grow in fields. Think of all the different textures, shapes and colours of the fields.

Look at this photograph taken from the air. Does it remind you of anything?

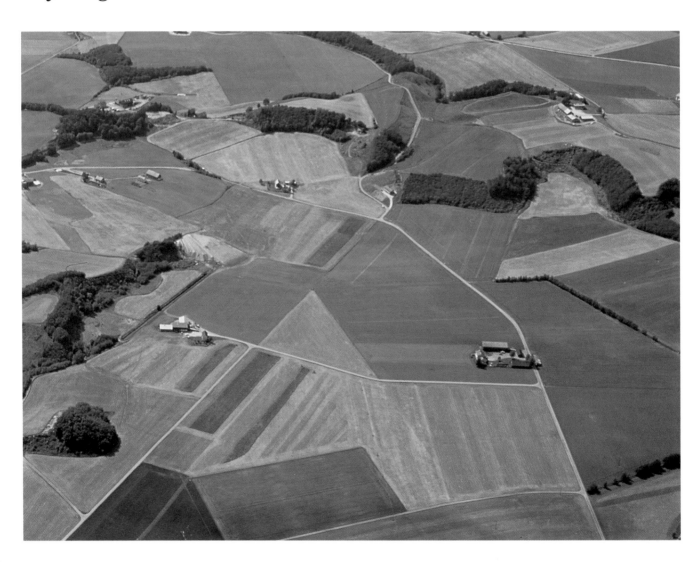

Collect a variety of countryside colours from the pages of old magazines. Make separate piles of the different colours.

- Draw your bird's-eye view of the landscape on the card. Just draw the shapes of the fields.

- Tear your coloured paper and magazine pictures into different shapes and sizes, like the fields in the photograph. Stick them down next to each other. Now you might like to stick down thin strips as hedgerows. See the patterns they make.

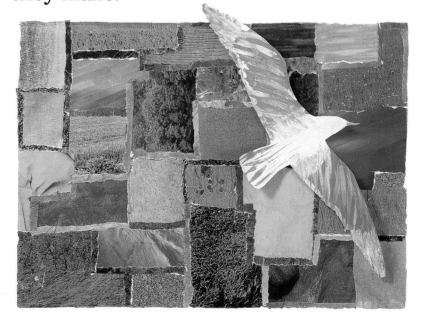

You could paint a picture of a flying bird. Make it big and stick it on to the landscape. When you have finished your collage, hang it on the wall.

15

Clowns

Look at these pictures of colourful clowns. Do you think they have funny faces?

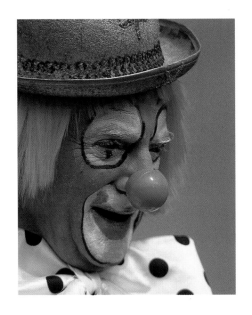 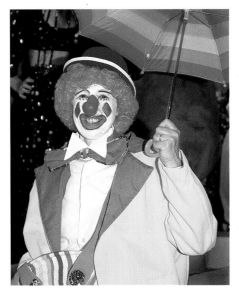 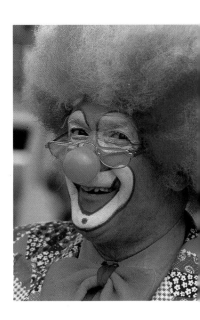

Draw a picture of a different clown. What colour will the nose be? Will the hair be curly?

You are going to make a collage of a clown. Look in your box at all the things you can use to make the face. You could use wood shavings or dried spaghetti for the clown's hair, bottle tops for the eyes, and sunflower seeds for the teeth.

You will need:

Your collage box

Scissors

Glue

Card

Paper

Pencil

- Cut out a piece of paper or fabric in the shape of the clown's face. Make it big. Don't forget the ears!
- Glue the face onto the card.
- Stick down all the other things you have chosen to make the face. Make your collage colourful.

When you have finished, think of a name for your clown. You could also make a collage of the Big Top, or the circus ring with lots of clowns.

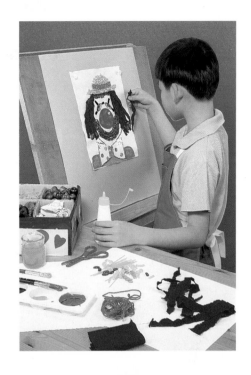

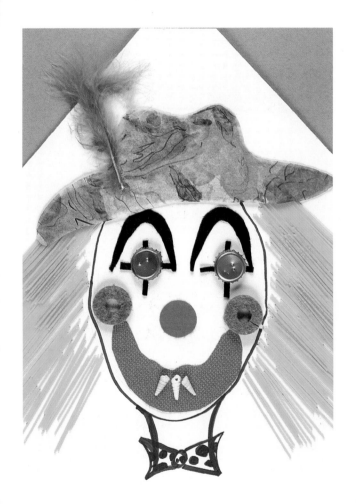

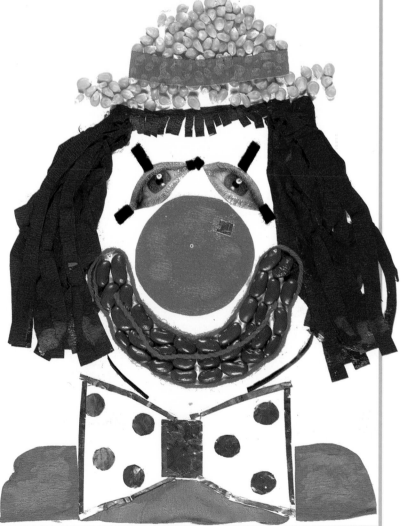

Wild animals

Think of some animals with interesting markings on their coats, such as leopards, tigers and snakes. What other animals can you think of?

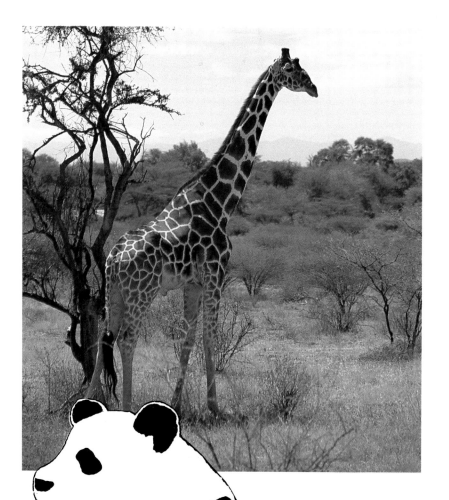

Now think of some black and white animals, like pandas. Can you think of some more? Now find some black and white pictures of wild animals.

Collect a variety of black and white materials to make a collage picture of an animal with interesting markings.

- Draw the outline of your animal on to the card. Make it big.
- Put in the background first. Will there be trees in your picture?
- Now make your animal. Tear and cut the papers and fabrics to make the shapes you want.

Next time, make a different animal with coloured materials. You could make a very big, colourful collage of Noah's Ark. Ask a friend to help you.

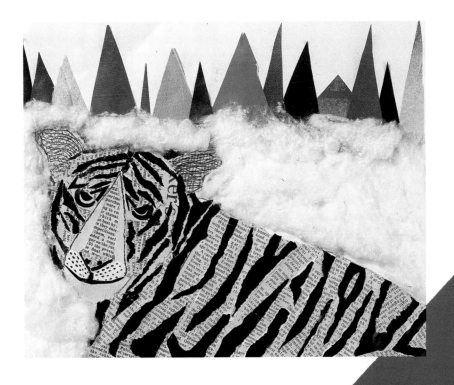

Under water

This picture was made by turning paper into pulp and pressing it into moulds. The artist made 29 pictures like this and called them *Paper Pools*.

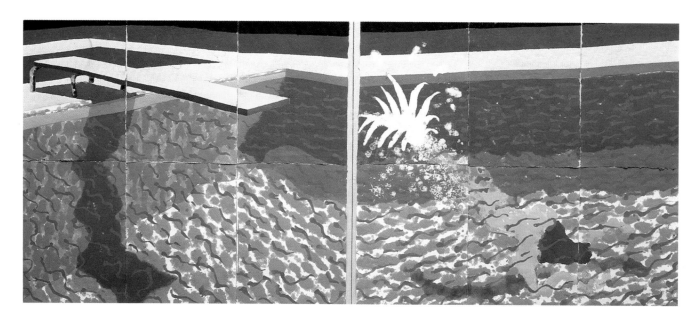

Le Plongeur (Paper Pool 18) 1978, 72 x 171" by David Hockney (b.1937).

Look at any pictures or books you have about water, swimming-pools, the sea, ponds, lakes and rivers. Look at the colours of the water.

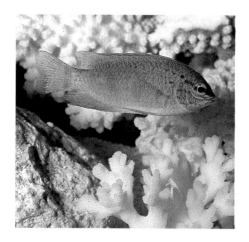

Now look at this photograph. See the brightly coloured fish.

Collect anything you can think of that would make an interesting collage of some fish.

- Tear your coloured tissue into different shapes.
- Overlap the shapes as you stick them down on to a very big piece of card to make a water collage.
- Make a collage fish on another piece of paper. Use beads, sequins and scraps of fabric or foil to show its scales. Use bright colours.
- Cut out your fish and stick it on to your water collage.
- Make some more fish, big ones and small ones. Stick these down too.
- Use some more torn tissue to stick over parts of the fish. See how they change colour.

You will need:

Pictures of underwater scenes

Magazines and holiday brochures

Coloured tissue in blues, greens and white

Fabric, beads, sequins, silver or coloured foil

Your collage box

Paper

Scissors

Glue

Card

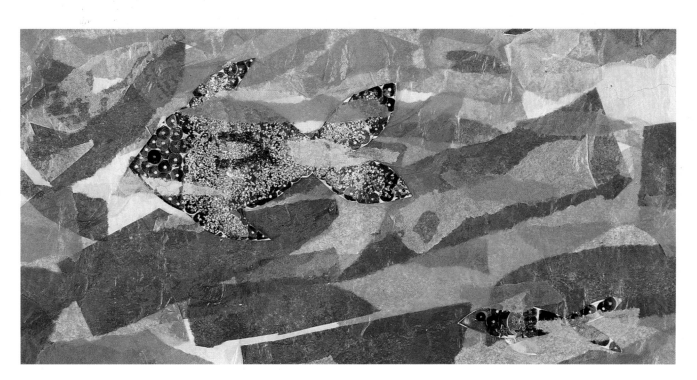

Rainforests

Think about all the different colours you would find in a rainforest. Would there be many different greens? How big would the plants and trees be?

Look at this painting called *Exotic Landscape*. It could have been a collage.

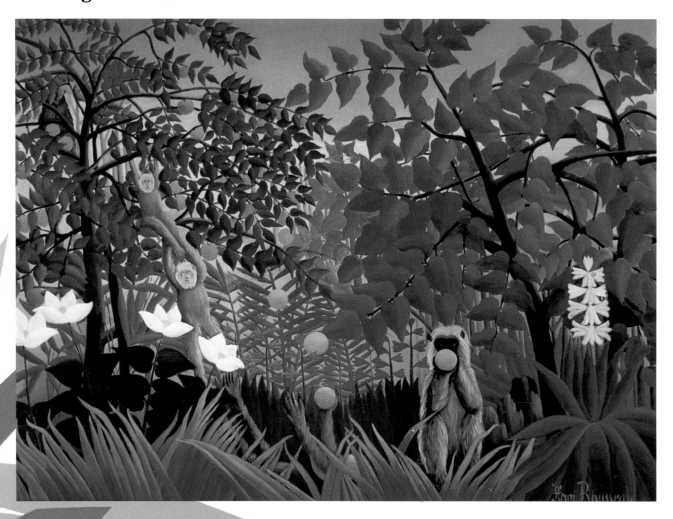

Exotic Landscape by Henri Rousseau (1844-1910).

Can you see the animals and plants? Are there any people? Will your collage have any of these things in it?

22

- Paste a strip of blue fabric right across the top of the paper. This is your sky.
- Cover the rest of the paper with a piece of green fabric. This is your background.
- Cut out lots of different sizes and shapes of leaves and trees. Do the same to make brightly coloured flowers.
- Lay them on to your background and overlap them. Do not stick them down yet. Rainforests have many different plants. Put the smaller leaves and trees at the top first and work down.
 Move them around until they look right.
- Now paste down a few shapes at a time. Start at the top and work to the bottom. Don't forget the birds and animals.

You will need:
Different types and colours of fabric, especially lots of different greens
Pictures of rainforests and jungles
Your collage box
Scissors
Glue
Card or thick paper

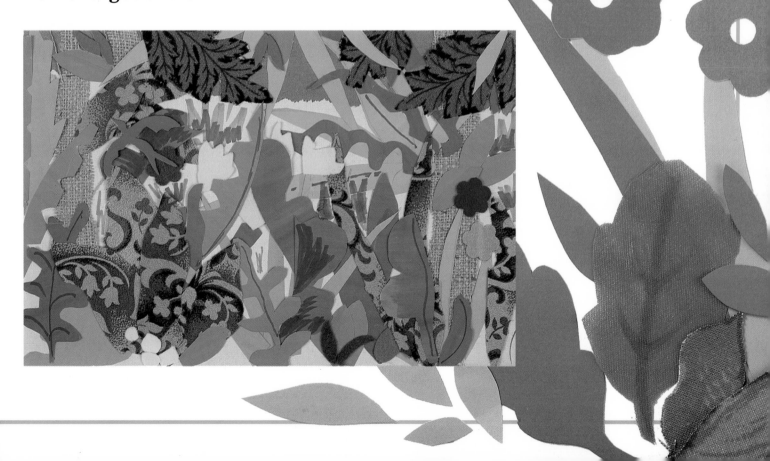

Butterfly wings

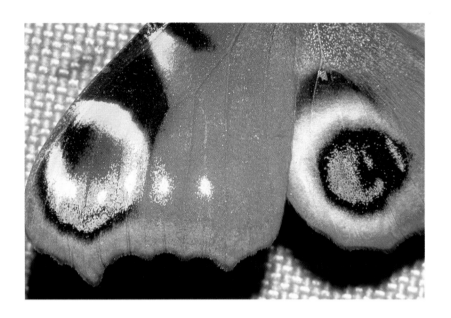

Look at this photograph. Can you guess what it is?

It is the wing of a butterfly in close-up. Look at the patterns. Can you make a picture like it?

This collage is also about butterflies. The artist has used cut-out paper.

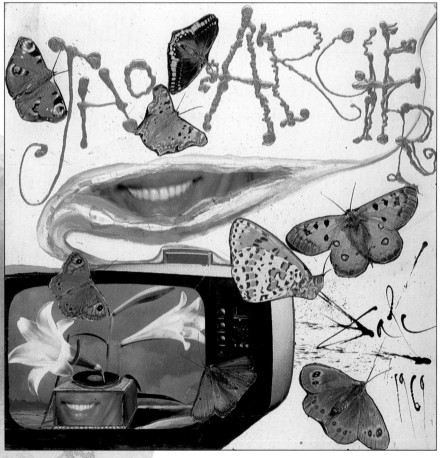

Marquette de Converture de Disque 1969
by Salvador Dali (1904 - 1989).

- Paint some water over a piece of paper.
- Mix some thin paint and brush a small circle of it on to the wet paper.
- Mix a different, bright colour and drop a little of it into the middle of the damp circle. See how the colours run. Let them dry. Try different coloured circles. You can use these to help make your collage.
- Take a small square of card, about 150mm square.
- Make your close-up of a butterfly wing using the Cellophane and tissue. Use anything else you think will help.
- Cut or tear out the circles you have painted. Stick these on.

Next time, make a whole butterfly. Cut it out and hang it from the ceiling.

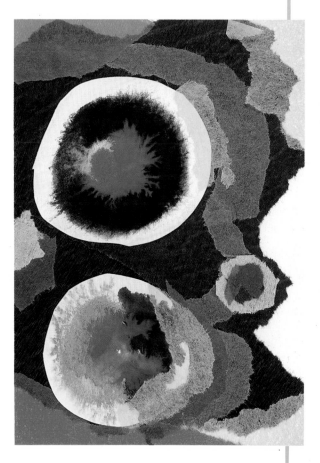

Mosaics

This is a picture of a Roman mosaic made about one thousand seven hundred years ago. Small pieces of coloured stone were stuck down in a pattern on floors and walls. Have you ever seen a mosaic floor?

You will need:

Box of gummed paper shapes

Coloured paper

Pencil

Paper

Ruler

Scissors

Glue

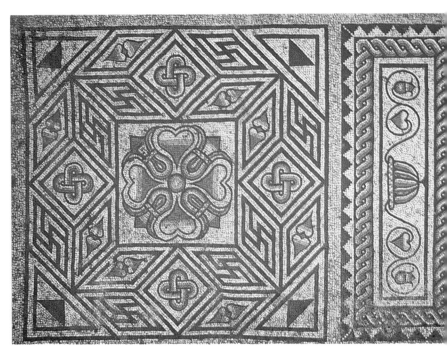

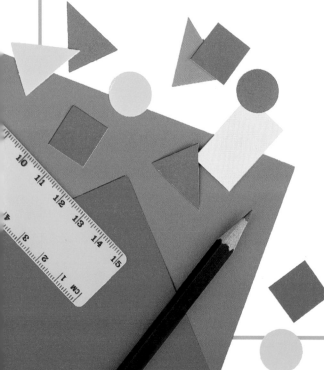

- Practise drawing some patterns.
- Keep your lines straight with the ruler.
- Make triangles, squares and rectangles.
- Choose your favourite patterns and draw them again carefully to make a picture.
- Use the gummed paper shapes to fill in your pattern.
- Cut and paste paper from bigger sheets too. Make your mosaic colourful.

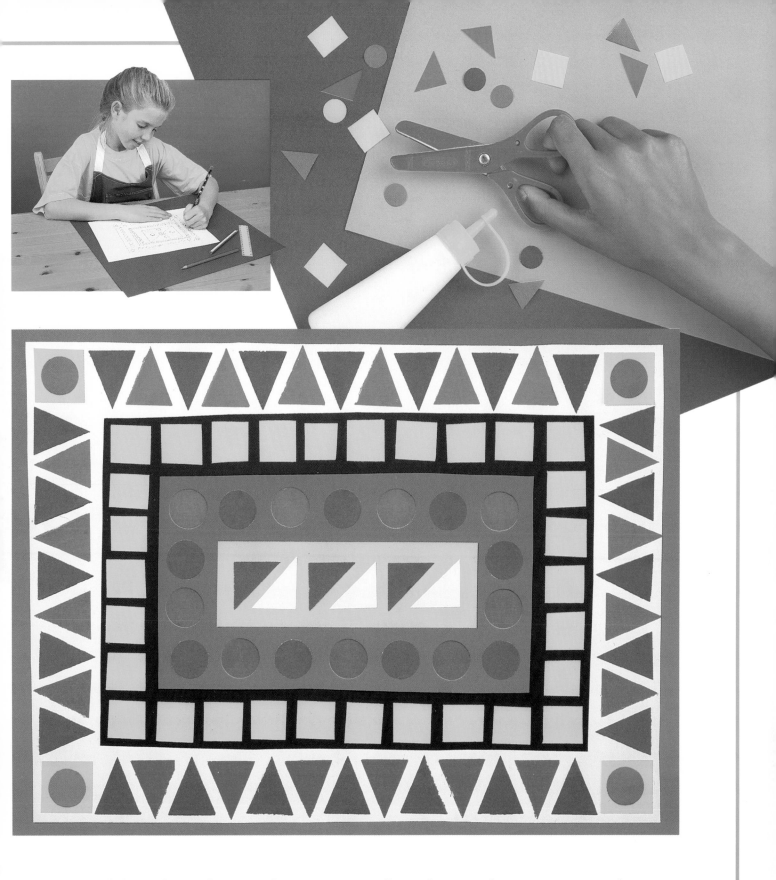

You could make a long, thin mosaic border and use it to make a frame for another collage or painting.

Look at this picture of vegetables, flowers and seed pods. See the interesting patterns they make.

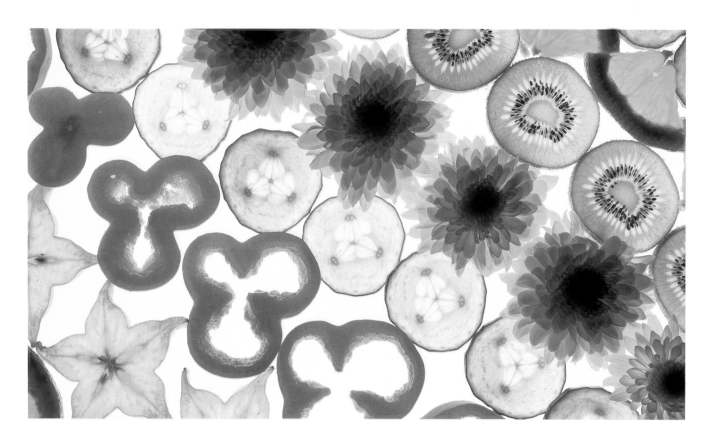

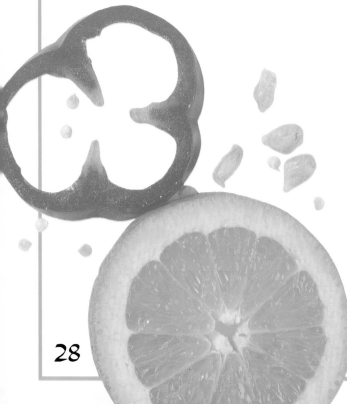

- Now you are going to make a collage of the shapes and patterns that you find in fruits and vegetables, like oranges, tomatoes and red peppers for example. Ask an adult to cut one in half for you.
- Draw the outlines of the patterns on to your paper.

Now you are ready to make your collage.

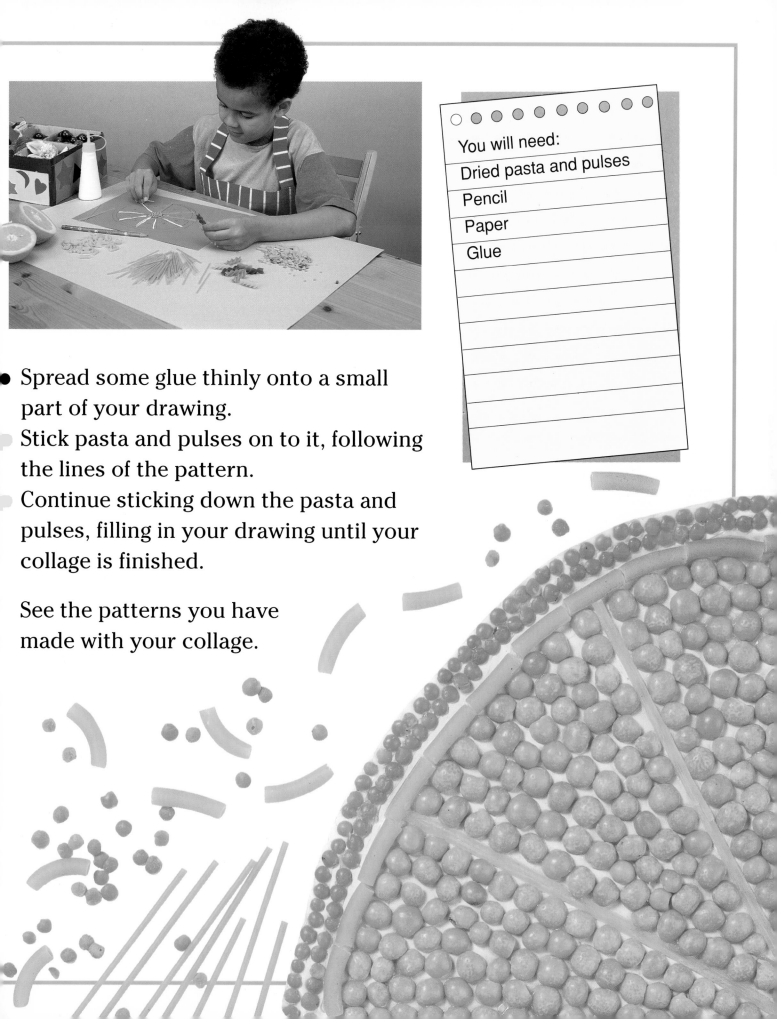

You will need:

Dried pasta and pulses

Pencil

Paper

Glue

● Spread some glue thinly onto a small part of your drawing.

Stick pasta and pulses on to it, following the lines of the pattern.

Continue sticking down the pasta and pulses, filling in your drawing until your collage is finished.

See the patterns you have made with your collage.

Notes for parents/teachers

FIRST ARTS & CRAFTS: COLLAGE introduces the child to collage in various forms. It is a technique in which almost any material can be used, in any scale. Inventiveness and experimentation are to be encouraged at all times. On a practical note, it is often the case that the background must be stuck down first and the collage is then developed in stages, adding and sticking materials on top as it progresses. Children may want to draw a picture onto which they will stick the materials. Generally, this doesn't work, but the fact that it doesn't work is an advantage, since children produce much livelier pictures when working freehand, as it were, with their materials. Sections of the book where developmental work is self-explanatory have not been included in the following notes.

What is collage? 4 - 5
Many of the materials such as dried pulses, beads, sand and sawdust, could be stored in glass or plastic containers. Although breakable, glass screw-top jars filled with different things are visually exciting and can provide a rich source of reference for drawing and painting from observation.

Windows 8 - 9
Collect different photographs together. Discuss further places where you find different window shapes and scenes. Encourage children to be imaginative. Introduce them to ideas linked with the past; temples, castles and dungeons for example, and with scenes in other countries. Discuss the chosen window shape. Who or what will be seen through the window? Will they be inside or outside? It could be a painting of the child's own bedroom or a view from another room in the house or classroom. A group activity could be a huge window. Each child could make and cut out something to put in the window. Make them large and overlap some side by side and top to bottom. A shop window would be a good example. Perhaps a toy shop. The children could use their own toys as reference. Windows have been a recurring theme for artists throughout history and they feature throughout this series too. An invaluable help for the windows theme, and indeed many other themes, is a series of postcard packs each containing twenty-four examples of artists' work, obtainable from Goodwill Art Packs (tel: 071 602 6465).

Faces 10 - 11
This exercise lends itself to much experimentation and variety. The faces can be assembled in an amusing way using different sized features on one head, which in turn could be added to a tiny body. Alternatively the child could produce a portrait in a similar way to an 'Identikit' face. They could try to produce a portrait of someone they know. The example by Arcimboldo could be made using real fruit and vegetables. Make a face on a plate. Use readily available produce which the children might like to eat afterwards. A class activity would be to produce a portrait of everyone in the form including the teacher, perhaps putting them on display in the corridor.

Stained-glass windows 12 - 13
Collect pictures of stained-glass windows depicting traditional and contemporary scenes and designs. There are wonderful international examples of both. Kaleidoscopes offer another rich source of pattern and colour. A class or family extension of this work would be to create a very large window and work on it together. With some assistance, children can produce wonderfully creative stained-glass pictures of well-known stories, historical events or Christmas themes such as the Nativity. Encourage children to look at the differences in torn and cut paper effects, and at the tonal ranges in the overlapping colours.

Bird's-eye view 14 - 15
Discuss the views of the countryside that the children are imagining, then compare them to aerial views of villages and cities. Show photographic examples of both. How do the shapes and colours differ? Ask who has been high above the ground in an aeroplane, hot air balloon or very tall building? What did they see? An addition to this work would be to show the children some of the many interesting and unusual examples of aerial photography such as the one featured in this project. Lastly, photographs taken of the earth from space can be very inspirational. This exercise is also excellent for painting and clay work on small individual tiles which can be joined together later. Cross-curricular work includes creative writing, drama, geography and science.

Wild animals 18 - 19
Show examples of animals with interesting coats and markings; snakes, snails, big cats, insects, etc. It is useful to have some black and white examples to help the child see the possibilities of working in black and white only. Encourage originality. Newsprint, for example, can produce interesting results, especially when contrasting sizes of print are used. Silhouette work could also come from this. In class Noah's Ark could be made into an enormous frieze stretching around the walls. This is a wonderful starting point for work on patterns in nature as a major cross-curricular topic. On a practical note, the child may find it difficult to create a collage without drawing an outline of the animal. Either stick smaller pieces of material *around* the drawn animal to create background *or* fill in the background, then draw the animal on paper or fabric, cut it out and paste it down, adding markings on to it.

Under water 20 - 21
An extension of this work with older children would be to link it to swimmers in water. Visit a public swimming pool - and take photographs of people swimming. Look at the distortion. This is often shown in tile pattern too. David Hockney has made many different studies of water in swimming-pools. With the children, compare examples of his pool work such as *The Splash, A Bigger Splash,* and *Le Plongeur (Paper Pools)*. He has also produced some excellent photo-montages of swimmers. Use similar materials to create collages, but substitute people for fish. Give an example to illustrate distortion by putting paint brushes in a glass jar half full of water, then ask the children to draw the refraction.

Rainforests 22 -23
There are several examples of Rousseau's work on jungles, in particular *Tropical Storm with Tiger, The Snake Charmer* and *Tropical Forest with Monkeys.* Use these as a starting point for discussion. Pictures of tropical birds and plants might help, but children could make up their own. Encourage them to think about the scale of the plants - think BIG, especially for leaves. Some house plants such as the rubber and Swiss cheese plant would be good for observation. If possible, visit a tropical glass house. Putting the smaller leaves and shorter trees at the back will create simple perspective. The large trees at the front could go off the page both top and bottom. Take the children for a walk in a wood or forest if you can. Discuss. How is it different to a tropical forest? This can lead to other work on the environment.

Butterfly wings 24 - 25
If possible, provide a hand lens or magnifying glass for children to look at real butterfly and moth wings. Ideally, a microscope could also be used to show a greater degree of magnification. Further work could include other small, detailed rectangles of various enlarged wings, progressing to very large sheets of collage based on the original smaller ones. This illustrates the concept of enlargement/magnification. Encourage children to think of different materials to use instead of tissue and Cellophane. Opportunities for cross-curricular links exist here, particularly with science.

Mosaics 26 - 27
This exercise introduces the child to shape, and links well with mathematics. Extension work in this category has many possibilities. These include large-scale mosaics of pattern or scene with good opportunities for group work. Try to show different sorts of mosaics. Kaffe Fassett's book *Glorious Inspiration* has some interesting examples. With older children, painted, then crushed, eggshells could be used for small-scale intricate work. Pour Plaster of Paris in a suitable, shallow container and set broken pottery pieces into it, or use beads, small pebbles and shells.

Patterns in nature 28 - 29
This work also has endless possibilities. Collect as many interesting examples as you can. You could include dried sunflower heads, skeleton leaves, cross-sections of poppy heads, pomegranates and red peppers. Cut open a red cabbage and suggest using string stuck down to create the pattern. Look at the two different effects achieved. Use seeds from melons, rice and other grains instead of pasta. Further work with enlargement and magnification would work well.

Further information

Glossary

Bird's-eye view Seen from above, as if by a bird.
Close-up A very close view of something.
Collage A picture made by sticking down different materials on to paper.
Corrugated card A type of card with ridges and grooves.
Frame The border around a picture or window.
Mould A container into which a soft material is put and left to get hard. When it is hard, the material becomes the same shape as the mould.
Overlap Laying part of one thing over part of another.

Pattern Shapes and colours that are repeated.
Pods The cases that hold the seeds of some plants, such as peas.
Pulp In this book, a soft, wet mass made by mashing paper with water.
Pulses Some plants have seeds which can be eaten. The seeds are known as pulses.
PVA glue Water-based glue.
Stained glass Coloured glass.
Synagogue A Jewish place of worship.
Texture The feel or look of a surface.

Index

Acknowledgements

The publishers wish to thank the following for the use of photographs:
Bridgeman Art Library, London for David Hockney's *Le Plongeur (Paper Pool 18)* 1978, 72 x 171" Coloured Pressed Paper Pulp (12 panels);
Visual Arts Library for Giuseppe Arcimboldo's *Spring*; Marc Chagall's *The Twelve Tribes of Israel, Benjamin* © ADAGP, Paris and DACS, London 1994; Salvador Dali's *Marquette de Converture de Disque 1969,* © DEMART PRO ARTE BV/DACS 1994 and Henri Rousseau's *Exotic Landscape* 1910;
The Tate Gallery (London) for Peter Blake's *The Toy Shop* (page 8 and cover);
The Tate Gallery (St.Ives) for Patrick Heron's *Design for Big Window - Tate Gallery St. Ives: April 1992*;
Tony Stone Worldwide (Arnulf Husmo) page 14.
Additional photographs courtesy of Chris Fairclough Colour Library.

The publishers also wish to thank our models – Kerry, Anna, Manlai and Jeremy, and our young artists Sue and Rebecca.